KT-436-618

Interpreting
CARO

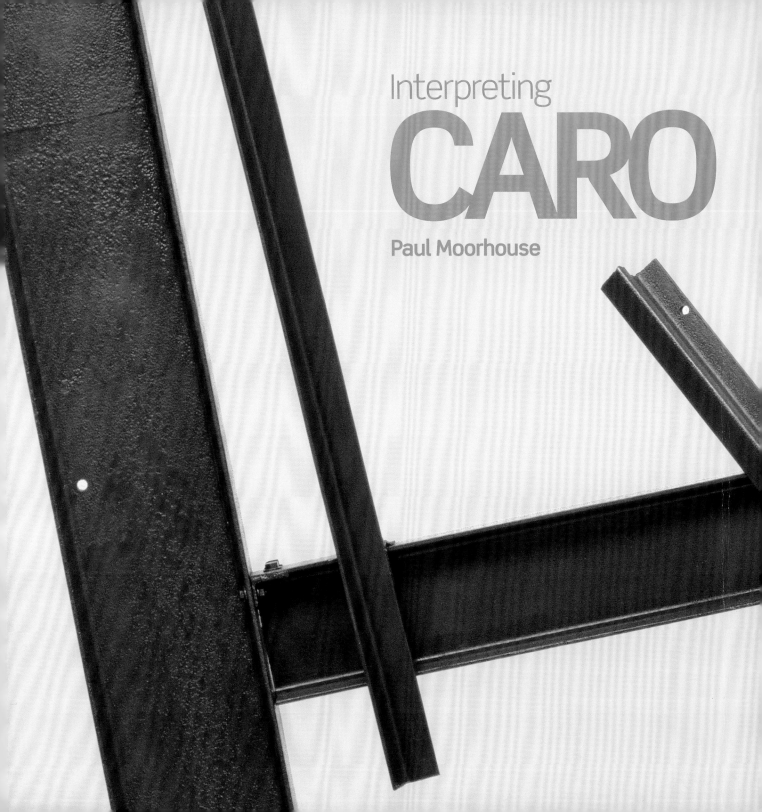

Interpreting
CARO

Paul Moorhouse

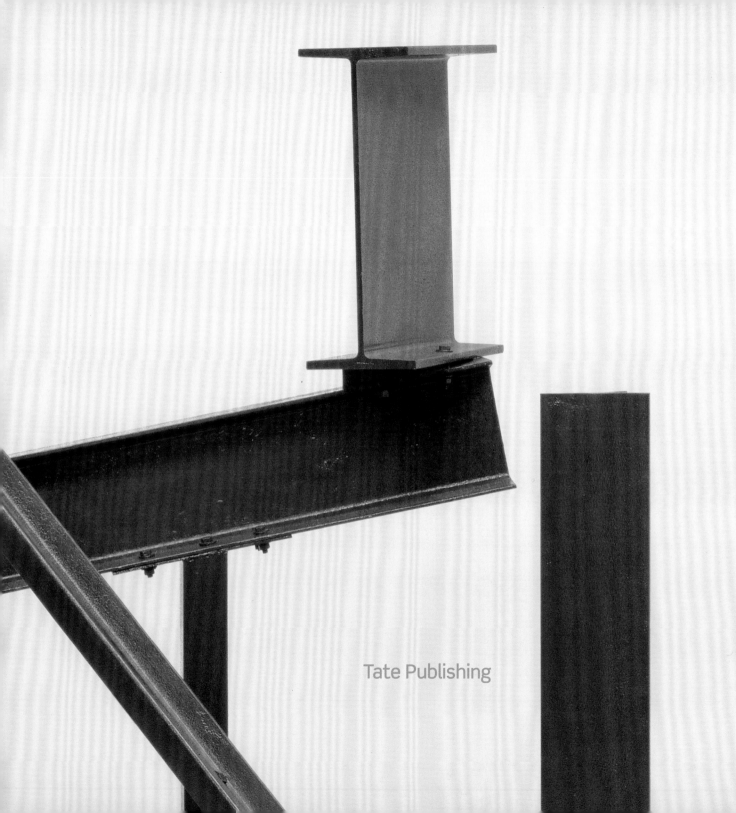

Tate Publishing

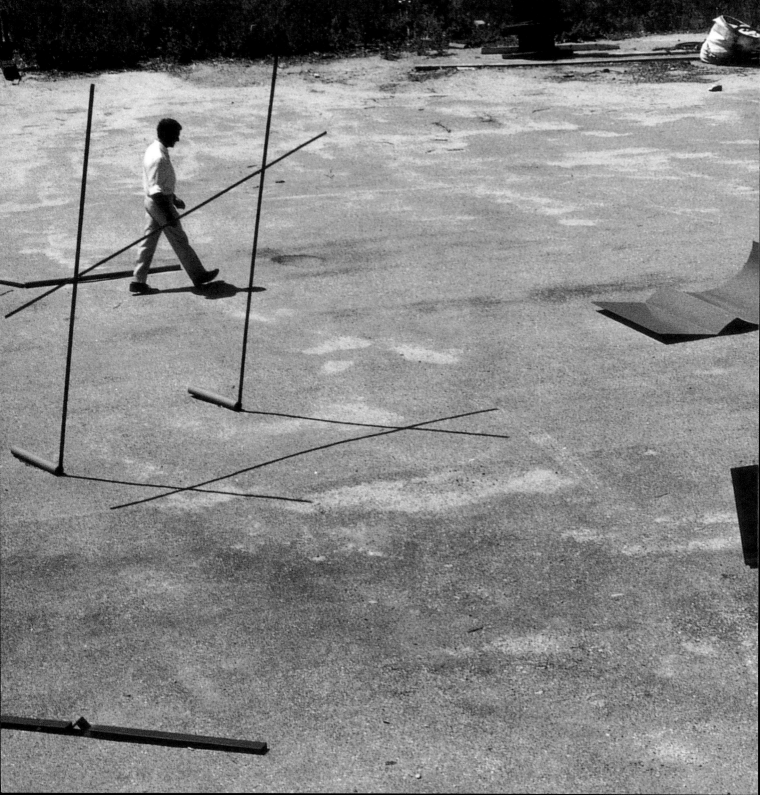

It is Anthony Caro's enduring achievement to have changed the course of sculpture. The abstract constructions in painted steel that he began to make in 1960 heralded a revolution in the way sculpture was made and understood. Instead of recognisable imagery, Caro's sculpture referred to nothing outside itself. It abandoned conventional methods such as carving in stone or wood, or modelling in clay and then casting in plaster or bronze. In their place, the new sculpture used pieces of scrap steel – girders and sheet metal – bolted and welded together, and then painted in bright colours. In a striking departure from tradition, he rejected the creation of solid, closed forms for an engagement with space and the open arrangement of shapes. Breaking with the principle of displaying sculpture on a pedestal, he situated his art in the real world. No longer confined on a plinth, as if occupying an imaginary space, Caro's work stood directly on the ground. These developments were highly influential, overturning ideas regarding the subject, materials, appearance and potential of sculpture. The effects of that revolution continue to resonate.

Anthony Caro, Bennington, Vermont, 1966

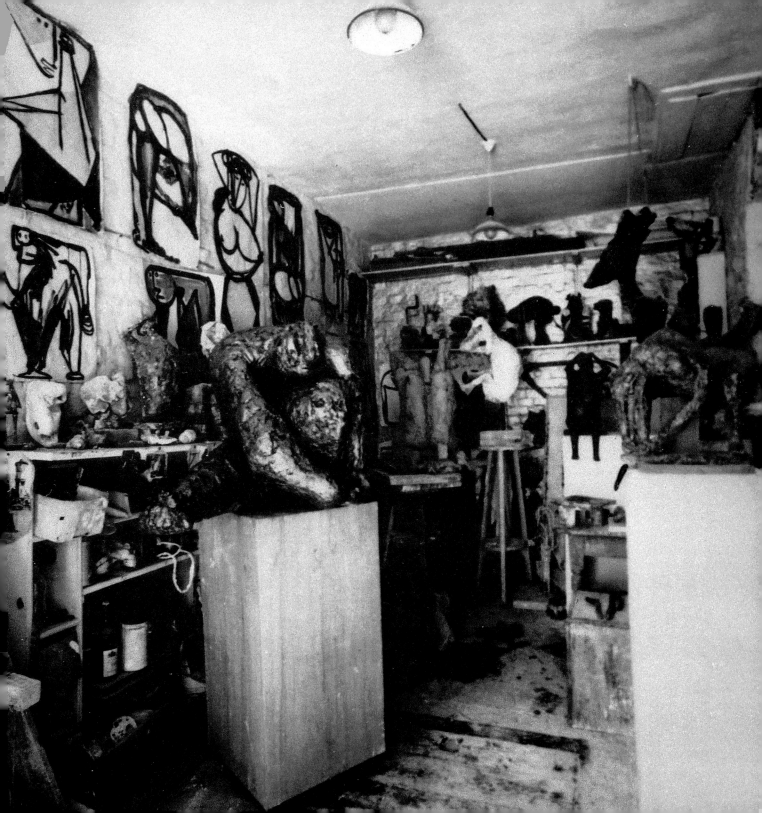

Caro's breakthrough – when it came – was radical, decisive and quick. But it occurred relatively late in his career. In 1960 he was thirty-six years old and had already made a reputation as a highly original sculptor. In the preceding six years he had made over thirty sculptures. These works – strange lumpen figures, heads and animals – are impressed with rocks, pebbles and a burgeoning sense of their own material presence. Significantly, they show no trace of the influence of Henry Moore, with whom he had spent two years as an assistant earlier in the decade. Reacting against the smooth surfaces of Moore's carved forms, Caro's figurative sculptures investigate the expressive potential of clay – freely modelled, beaten, subject to the intervention of chance. He would drop and hit the soft material, so that the resulting shapes suggested forms that could then be developed imaginatively. The figures which emerged are massive and ungainly, their surfaces encrusted with fragments of cast objects. They have a raw, vital, primitive character. *Woman in Pregnancy* 1955 , for example, recalls one of the earliest known sculptures, the so-called *Willendorf*

Venus (see p.8), thought to have been made around thirty thousand years ago. Both works are an evocation of female fertility and, in the case of the Caro, gestation. In both cases the figure's stomach is swollen, the breasts and buttocks fleshy and heavy. Both sculptures focus maximum attention on the body in order to convey a sense of physical weight – as it is lived and felt.

Indeed, Caro's subject in these works is how it feels to be inside the body – standing, turning, twisting, rising, lying on the ground and so on. For example, in lying down there is a sense of one's own weight pressing on the ground. He explores these different experiences, employing distortion and exaggeration to infuse the clay with a sense of inner life and sensation. *Man Taking Off his Shirt* 1955–6, for example, reduces the head to proportions that, in terms of literal appearance, appear small in relation to the body. However, in departing from straightforward imitation of the look of the subject, the sculpture appeals to the imagination, recalling a sense of how the action being performed *feels*. There is an emphasis on

Caro's studio in
Hampstead, 1955

Early work

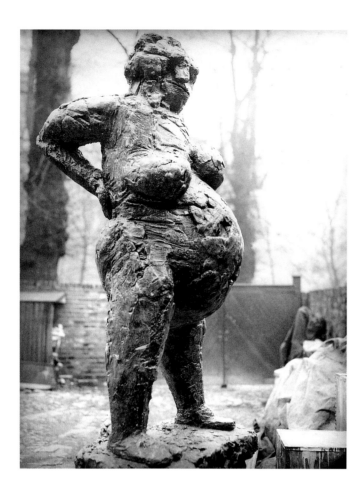

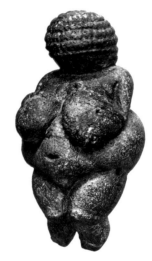

Woman in Pregnancy
1955
Plaster
200.7 cm high
Destroyed

Willendorf Venus,
c.30,000 – 18,000 BC
Naturhistorisches
Museum, Vienna

the weight of the arms, the awkward twist of the body, the struggle against the downward pull of gravity. Other sculptures address more fleeting, subtle sensations. In *Cigarette Smoker I – Lighting a Cigarette* 1957 , inhalation – sucking in – is central. The actions evoked by these early works are deliberately unremarkable, almost banal: many were based on photographs found in newspapers that seemed to catch a particular moment. They are located firmly within the realm of the everyday, suggesting, through the expression of these familiar sensations, that Caro's underlying concern is to explore the nature of being alive.

The will to make his sculpture more real, to make the experience of it more immediate, led to one of Caro's most important and influential innovations. In 1959, for the first time, he placed a figurative sculpture, *Woman's Body*, in the real world. This imposing figure – somewhat larger than life-size – is seated on a bench. Her upper legs are jutting out and – significantly – her feet are in direct contact with the ground. By presenting the work in

Woman's Body 1959
Plaster
188 cm high
Destroyed

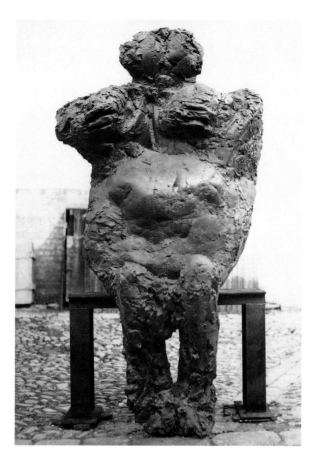

this way, Caro overturned the tradition of pedestal-based sculpture. A pedestal, or plinth, is to sculpture what a frame is to a picture. It defines an imaginary or virtual space in which we are able to view the work of art as a representation of some other thing. Taking sculpture off the plinth and placing it on the ground is significant because it situates the sculpture in the viewer's space: in the real world of people and objects. It makes the experience of the sculpture more direct.

Eliminating the plinth was, in physical terms, a small step. But it was rightly seen as breaking down a long-standing barrier around sculpture. As a result, this advance was widely imitated and has since become a convention for most contemporary sculpture. *Woman's Body* was a decisive move: it was, however, incomplete. Although the sculpture had been brought into real space, it was still not possible to experience the sculpture as a thing in itself. It still represented something else – a human figure. The will to make his sculpture more *real* – as an object in its own right, which we experience directly – is the key to Caro's subsequent breakthrough into abstraction. He explained: 'I felt the figure was getting in the way . . . I had no alternative but to make my sculpture abstract if it was to be expressive.'

**Cigarette Smoker I –
Lighting a Cigarette** 1957
Bronze
32 × 19 × 27 cm
Collection of the artist

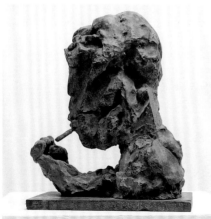

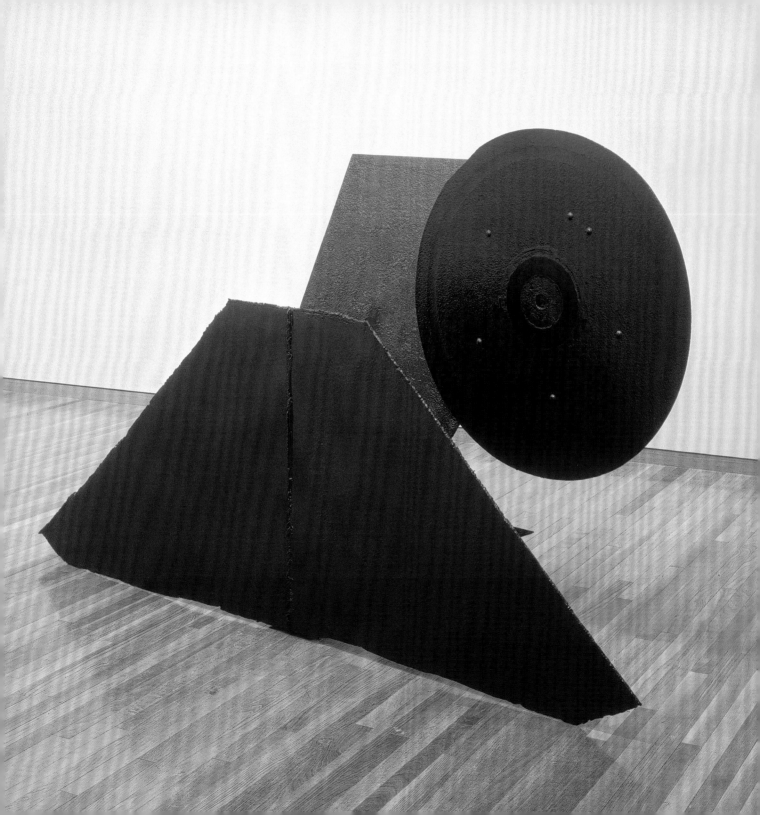

The desire to make his work more real led Caro into the unfamiliar territory of pure abstract form. The momentum for taking this step had been confirmed in 1959, following a visit by the influential American art critic Clement Greenberg to Caro's studio in Hampstead, north London. Greenberg was critical of Caro's figurative work, criticism that was nevertheless intended in a constructive, positive and friendly way. Caro sensed the value of Greenberg's insights, in particular the American's advice: 'If you want to change your art, change your habits.'

Later that year, Caro visited the USA for the first time. He spent two months travelling, during which time he met the painter Kenneth Noland in Washington. Later in the trip, Caro spent some time in New York and was able to see an exhibition of Noland's circle paintings and a single sculpture by David Smith. Caro was impressed and intrigued by Noland's work, responding to its freshness and clarity. Around the same time, Caro renewed his acquaintance with Greenberg. At a dinner given by Robert Motherwell and Helen Frankenthaler, Caro was introduced to Smith. Caro knew and admired

Smith's work from photographs and the sculpture he had seen, and they later spent an evening together, exploring Chinatown. It would, however, be another three years before Caro got to know Smith's work better. In terms of Caro's breakthrough to abstraction, of major significance was a second meeting with Noland in New York when the two men spent an entire night joined in discussion. Noland spoke about abstract painting and he referred to his practice of keeping the canvas flat while he was working on it. The idea of working blind, as it were, fired Caro's interest and he came away determined to try 'to make a kind of Noland'. On his return to London, he sought out scrapyards and docks where he was able to purchase a range of scrap steel pieces, including girders and sheet metal, and he learnt how to use oxyacetylene welding equipment. The result was his first abstract steel sculpture: *Twenty Four Hours* 1960.

Nothing like it had existed before. Caro seems positively to have denied any reference to the figure. Previously, sculptors had used solid, upright forms to represent the human body. In the pursuit

Twenty Four Hours 1960
Painted steel
138.5 × 223.5 × 83.8 cm
Tate. Purchased 1975

A new reality for sculpture

of a purer expressive language, such associations could be expunged. Echoing the language of Cubist painting, Caro replaced solid forms with an open arrangement of shapes. These non-referential forms were organised horizontally, and structured solely in terms of internal relationships. Continuing the advance made in *Woman's Body* in the previous year, *Twenty Four Hours* stands directly on the ground. From the outset, Caro appears to have recognised that the danger of positioning a sculpture in the real world is that it implies that the work of art takes its place alongside fabricated, functional things such as tables and chairs. This, however, is precisely the reason for Caro's insistence on his early abstract sculpture being for looking at only. Its non-functional nature defines it as art.

In works such as *Midday* 1960 and *Lock* 1962, we witness the development of a mature vision. As the viewer walks around these sculptures, a complex changing display of abstract shapes and spaces gradually unfolds – an experience that recalls the progress of a melody. Of these developments, Caro commented:

I have been trying to eliminate references and make truly abstract sculpture, composing the parts of the pieces like notes in music. Just as a succession of these make up a melody or sonata, so I take anonymous units and try to make them cohere in an open way into a sculptural whole. Like music, I would like my sculpture to be the expression of feeling in terms of the material, and like music, I don't want the entirety of the experience to be given all at once.

Such sculptures may also be understood in terms of human expressive gestures, evoked through the arrangement of shapes and the relationships between them. This can be seen in *Sculpture Two* 1962 (see pp.2–3). Composed almost entirely of beams, these parts extend, probe, stretch, reach and recline. The piece offers an ever-changing flow of inflections as the viewer walks around it. The effect is that of animation. The sculpture appears charged with a sense of inner dynamism – of immanent life – conveyed through seeing its structure constantly changing.

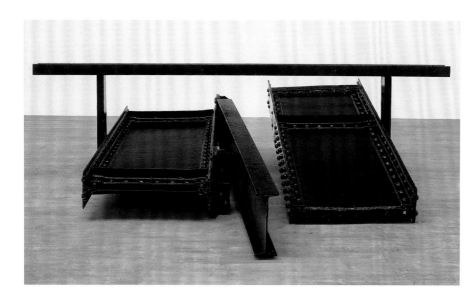

Lock 1962
Steel, painted blue
88 × 536 × 305 cm
Private collection, UK

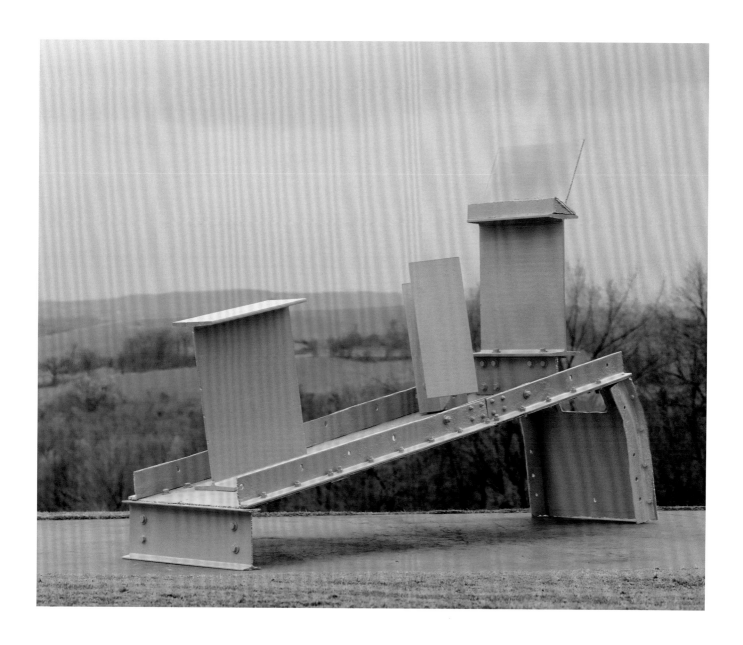

Midday 1960
Steel, painted yellow
240 × 96.5 × 366 cm
The Museum of Modern Art,
New York

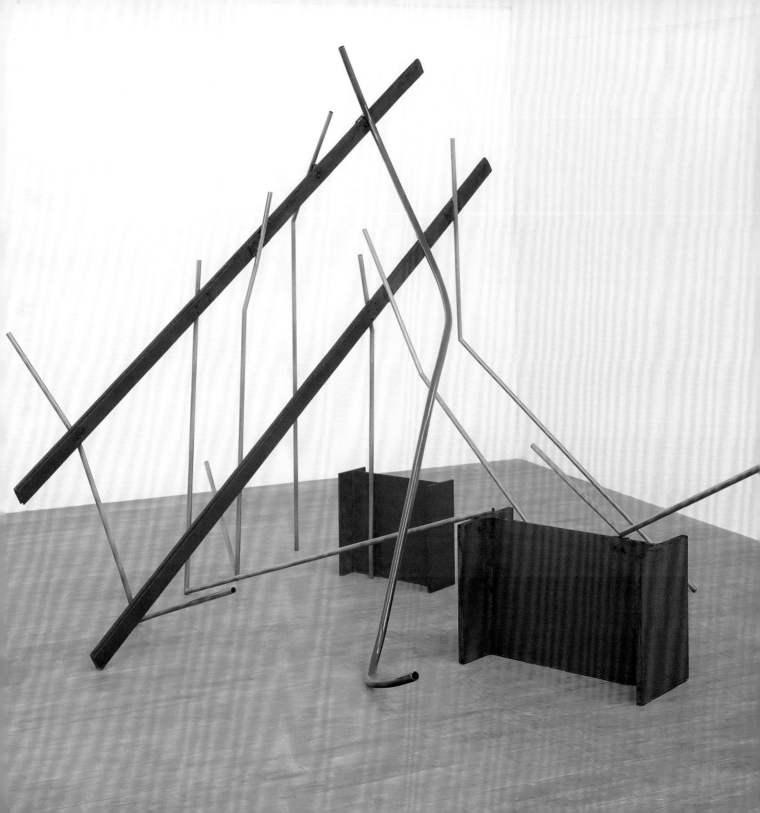

During the 1960s the main line of Caro's develop-ment was his exploration of *space*. Thinking in spatial terms was liberating, enabling the new sculpture to proceed, unfettered by distracting references. The ever-broadening range of Caro's work during this period attests the extraordinary flexibility won through the adoption of this spatial premise. In *Early One Morning* 1962 (p.16), sculpture as solid object has been consigned to history. Apparently weightless and without mass, the work defines and articulates space with extreme economy. Borrowing from the language of painting, a vertical rectangle of red acts as a kind of background at one end of the sculpture. Caro achieves a remarkable sensation of depth by positioning various other elements in front of this shape. The impression is of pictorial space advancing *towards* the spectator, an experience without precedent in the language of sculpture. It is with surprise that the true depth of this space is revealed as the viewer takes a side view of the work and the dramatic length of the horizontal connecting beam becomes apparent. Rightly regarded as one of his greatest early abstract sculptures, the realm it occupies seems light-years away from the world of massive, scabrous figures that Caro had inhabited barely three years earlier.

The sense of elan conveyed in *Early One Morning* arises from a poetic association of excursions into several other areas of artistic expression. Sculpture speaks to painting. Its graceful, sinuous lines also call to mind dance, gesture and drawing. This light, dancing quality was something very new to sculpture, very much a break with the monumental figurative tradition. It is continued in other works made around this time, notably *Hopscotch* 1962 (p.17) and *Month of May* 1963. In the earlier work Caro forgoes colour, preferring to preserve the aluminium in its natural state, whereas in *Month of May*, he goes in the opposite direction, differentiating the various elements through the use of several colours. In *Hopscotch* the horizontal elements form a kind of musical stave within which the sculpture dances a syncopated rhythm but *Month of May* is slower, more fluid and tends towards drawing. The eye becomes a coloured pencil as it follows the sculpture in its inscription of space.

Month of May 1963
Steel and aluminium,
painted magenta, orange
and green
279.5 × 305 × 358.5 cm
Private collection

Exploring Space

Early One Morning 1962
Steel and aluminium,
painted red
289.6 × 619.8 × 335.3 cm
Tate. Presented by the
Contemporary Art Society 1965

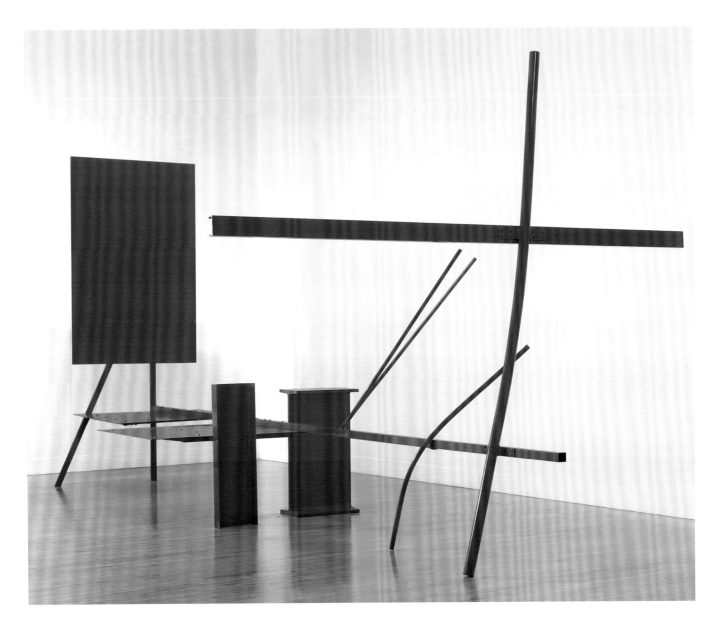

Linearity is a defining characteristic of Caro's sculpture during the mid-1960s. It is as if he was probing the question of how much 'flesh' one could take away and yet still be able to make a sculpture. In part, this direction seems to have been encouraged by Noland, with whom Caro continued to maintain a fruitful dialogue. The context for this renewed contact was his acceptance, in 1963, of a teaching position at Bennington College in Vermont, an appointment that, with the exception of a break in the autumn of 1964, he continued as a visiting faculty member until 1965. 'I remember Ken saying to me,' Caro recalled, '"The one objection I have to your English work is that it's too complicated . . . Why don't you work simpler?"'

The works that Caro went on to make in America are sparer. *Bennington* 1964, for example, snakes along the ground, turning and pausing, evoking qualities of extension and expansion. Yet this aesthetic could be, and was, pushed further. The painter Jules Olitski, who was also on the staff at Bennington, advocated yet more reductiveness. At this time, Olitksi's paintings were tending to ever-greater emptiness and this crept into Caro's work. *Eyelit* 1965 (p.18) takes to an extreme the principle of a naked sculptural gesture: a line drawn in steel through the air or along the ground. Testing the boundaries of sculpture and drawing, it explores how far an artistic statement in three-dimensions can be emptied out and still remain expressive: sculpture invested with feeling, but stripped to essentials.

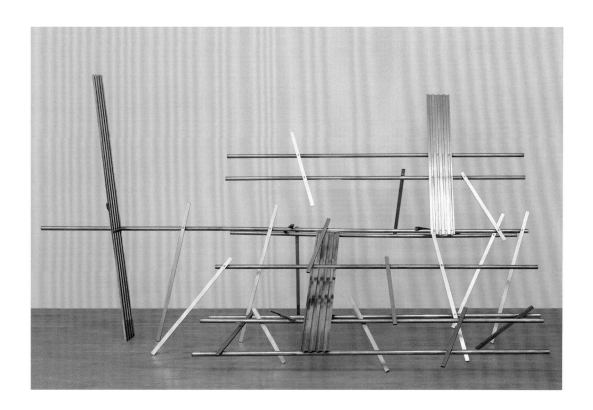

Hop Scotch 1962
Aluminium
250 × 213.5 × 475 cm
Private collection, UK

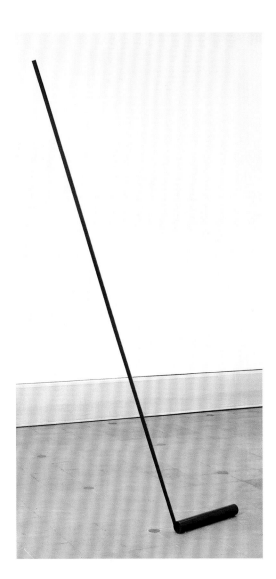

The 'naked' sculptures, as Caro sometimes refers to them, approach the limits of immateriality. They exist, but only just. As he now recognised, proceeding would entail re-clothing the work. This must have presented something of a problem since, having brought the articulation of space within the domain of sculpture, a return to solid form was out of the question. Caro's solution is both elegant and inspired. From 1966 a new formal element – the mesh panel – enters his vocabulary. Making its first appearance in *Aroma* 1966, it reappears in a number of guises in several subsequent works, before receiving authoritative treatment in *The Window* 1966.

Here, for example, it is used in much the same way that, in architectural terms, a wall serves to contain or define an area. In conjunction with a square panel of sheet steel and various other elements, it encloses a central space. This is a place that the viewer is invited to enter – but, unlike architecture, with the eyes only. The mesh puts flesh back on the sculpture, but its principal virtue is the way it achieves this without entailing heaviness. Being semi-transparent the mesh neatly avoids obscuring the rest of the sculpture, which can be glimpsed through it. Caro saw this as analogous to the presence of glass in a skyscraper. Although such architectural connotations were far from his thinking at the time, there is no doubt that Caro's treatment of space in *The Window* signals a growing engagement with concerns that had, hitherto, been the exclusive domain of architecture.

Eyelit 1965
Steel, painted blue
286 × 168 × 7.5 cm
Collection of
William S. Ehrlich

The Window 1966–7
Steel, painted green and olive
217 × 374 × 348 cm
Tate. Lent by a private
collector 1994

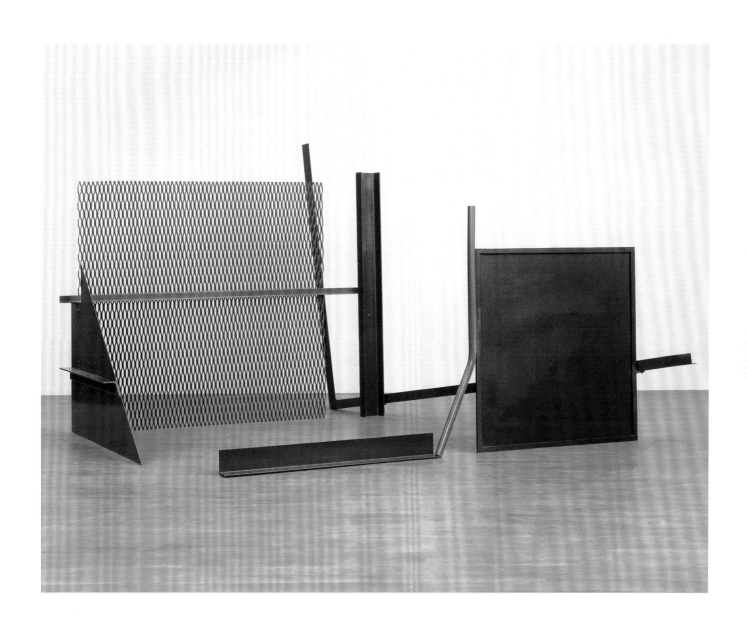

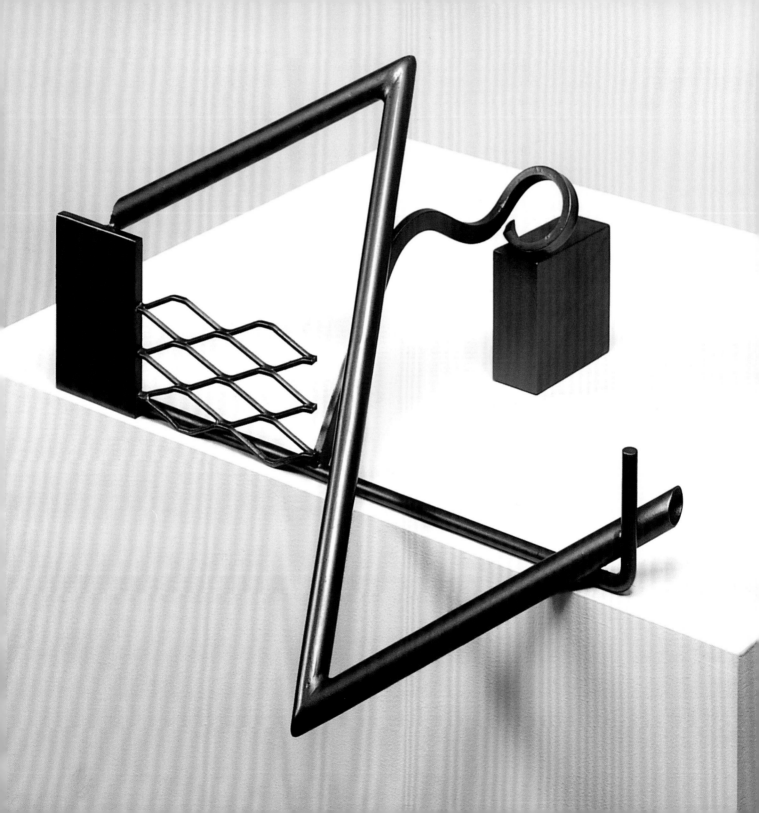

Placing his sculpture directly on the ground was a hugely influential innovation, much imitated by other sculptors. But having pioneered the way, Caro now found the territory becoming over-crowded. His recognition of this situation led to a further, singular invention. Caro's table sculpture, which dates from 1966, responded to the growing tendency for sculptors to place their work on the ground – by taking the opposite course. Returning now to working on a smaller scale, he addressed the problem of how to place sculpture on a plinth without implying that such works were maquettes for larger sculptures. Underlying that issue was the familiar problem that placing any sculpture on a plinth segregated it from the real world, inviting the perception that such works existed within a virtual space as the representation of some other thing. His solution to these questions was inspired and utterly original.

Table Piece VIII 1966 (p.22), for example, incorporates the handles of scissors. These elements are instantly recognisable as tool parts. They therefore establish a real scale, which relates to the human hand, banishing any implication of represented scale.

But they also function simply as ovals, which trace a tiny curving movement through space. These shapes are thus nicely poised: unmistakably functional in origin, but rendered abstract and expressive by their new context as art.

However, Caro did not stop there. A connected tubular shape is balanced against the table edge; also, a curved part springs forward from the edge, inscribing a movement that descends below the tabletop. The sculpture passes from the space of the plinth, spilling into the surrounding space. In this way it connects with the real world. Consequently, we encounter the work directly, as is the case with Caro's ground-based sculpture. The presence of shapes dropping below the table level is highly significant, making it clear that these small works can *only* exist positioned on a table top and that they cannot be made larger for siting on the ground. Like the ground-based sculptures, the table sculptures assert their intimate, close connection with the plane that supports them. In terms of scale, they relate to the viewer's hand, rather than to their height or length of stride.

Table Piece LIX 1968
Steel, sprayed silver grey
29.2 × 43.2 × 48.3 cm
Private collection, UK

Levels and planes

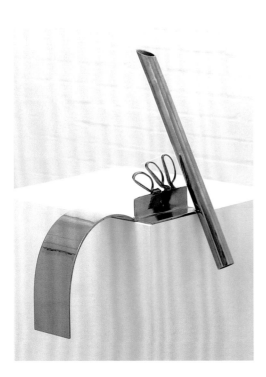

Table Piece VIII 1966
Steel, polished
68.5 × 33 × 50.8 cm
Private collection, UK

Table Piece XXII 1967
Steel, sprayed jewelescent green
25.4 × 80 × 68.6 cm
Private collection, UK

The first table sculptures seemed so intimate that, at first, Caro sprayed them with lacquer or gave them a polished, steel finish to emphasise their jewel-like character. This contrasts with the bolder, brighter, more assertive personality of the large works. Also, whereas the ground-based sculpture from the mid-1960s tends, in the main, to more complex structures, the table sculptures are more terse and economical, often comprising, as in *Table Piece XXII* 1967, a simple conjunction of two elements. The table sculptures feel like drawings, though not in the sense of being preparatory studies, for they are an end in themselves. But they have a spontaneity, and a surprising lightness of touch – almost as if the sculptor is sketching in three dimensions.

As is so often the case with Caro, a new, particular way of working opens up wider possibilities for exploration. The small works now fed back into his work on a larger scale. The theme of a raised level, below which elements of the composition are dropped or inflected, was taken up in earnest in the larger sculptures. *Prairie* 1967, announces this innovation and must be regarded as one of the artist's most remarkable sculptures. A perfect marriage of material fact and visual illusion, this work introduces an invention that is without precedent in the language of sculpture. A plane, comprising cantilevered horizontal rods in series, appears to float above the ground. Beneath this, other structural elements are deployed, connecting the plane and the ground. The work embodies

everything that had previously been denied to sculpture: it is open, expansive, weightless and transparent. Rather than standing up, as if challenging the viewer, it hovers – a strange, mute presence waiting to be discovered. The work's openness is a revelation, evoking the flat distance of landscape. Hitherto, this was a range of experience and reference that lay beyond sculpture's boundaries. At the same time, the work's flatness is pure pictorial illusion, an impression conveyed by the repetition of several surprisingly elongated rods. Once again, painting – and Noland in particular – seems to have been in Caro's thoughts. Parallels

can be drawn between Caro's use of repeated, highly attenuated lines, and Noland's paintings which then comprised ambitiously extended horizontal stripes.

Towards the end of the 1960s Caro made a group of masterly sculptures, each of which advanced the theme of level planes by involving more and more formal incident. In *Orangerie* 1969 (p.24) the level has become a kind of tabletop forming an integral part of the fabric of the sculpture itself. Then, in a significant extension of table sculpture, various curved forms, some of them ploughshares, are inflected above and below the

Prairie 1967
Steel, painted matt yellow
96.5 × 582 × 320 cm
Collection of Lois and
Georges de Menil

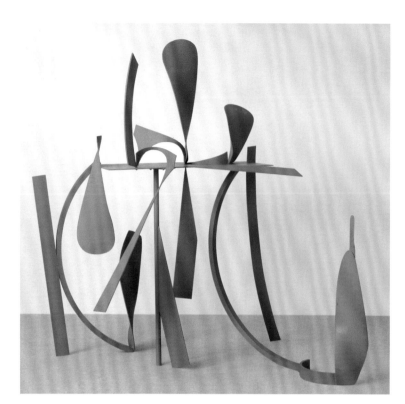

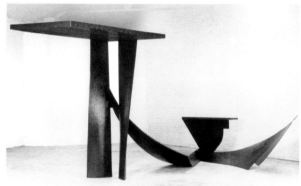

plane, connecting it to the ground. This theme is developed further in *Sun Feast* 1969, which sustains the illusion of a gravity-defying table-level in the midst of a chain of animated shapes. The table form suggests a connection with the world of recognisable things but the vivacious play of abstract form, and the illusion of weightlessness, define these works as art.

In *Deep North* 1969 the theme of level planes implies a relationship with architecture. The work incorporates two horizontal elements, raising one of them to ceiling height. The raised level defines a space beneath it and the viewer can walk around

the sculpture and even under it. The relationship between the sculpture and the viewer's body has drawn closer. However, physical occupation is not really the point. The viewer experiences the work in relation to his own height but the connection remains essentially visual. Moreover, the character of the work, with its great sweeping shapes, is assertively non-functional, uninhabitable and overtly expressive. Though the sculpture advances towards architecture, Caro simultaneously defines the boundary between the two activities: 'Architecture invites, sculpture is a thing in and of itself, architecture sits grounded, sculpture flies.'

Sun Feast 1969–70
Steel, painted yellow
181.5 × 416.5 × 218.5 cm
Private collection, USA

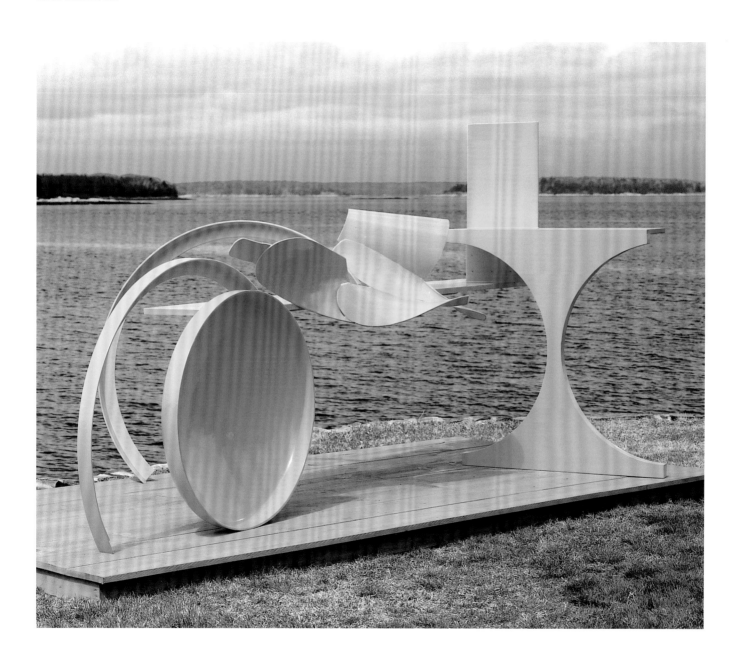

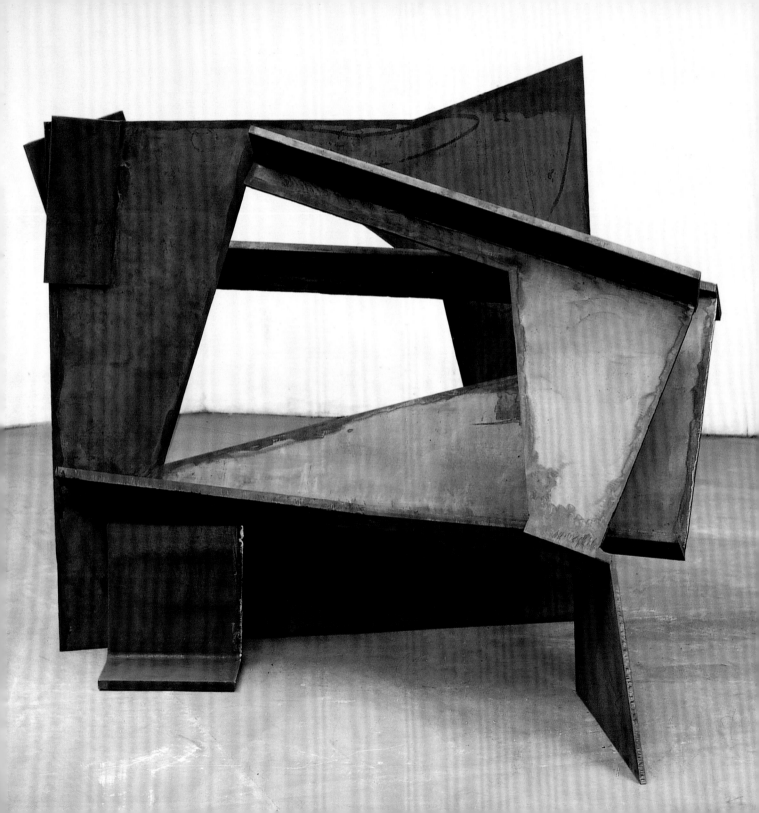

In 1970, on the occasion of Caro's one-man exhibition at André Emmerich Gallery, New York, Hilton Kramer wrote the following review in the *New York Times*:

> Mr. Caro stands today all but unrivalled as the most accomplished sculptor of his generation. He is unquestionably the most important sculptor to have come out of England since Henry Moore . . . If he continues on his present course, adding distinction and eloquence to an already powerful oeuvre, he must certainly be counted among the great artists of his time . . . One has the impression of an artist who, having totally mastered a new and difficult area of sculptural syntax, is now permitting himself a freer margin of lyric improvisation.

The exhibition included *Orangerie*, *Sun Feast*, and *Deep North*, and, as Kramer observes, there was a clear sense that with these sculptures Caro had attained mastery of the language he had been developing in the preceding decade. Despite the commercial success of the show and the acclaim it received, Caro himself had doubts: 'it was as if

I had been too successful . . . it was too much liked.' In part, these misgivings possibly arose from his perception that in the 'lyric' character of the work, noted by Kramer, lay the danger of over-refinement in the future. Perhaps there was a growing sense that the atmosphere of the times was changing and he felt a need to respond to that shifting outlook. By its very nature, Caro's sculpture has always had a restlessness – demonstrating a refusal to conform to the accepted view, either his own or that of others. Whatever the reason, he resolved to do the very opposite of the course advised by Kramer.

The Bull 1970 (p.28) signals the new direction that Caro now took. In some respects it resembles *Twenty Four Hours* 1960, the sculpture that marked his breakthrough to pure abstraction. Both works have a blunt, direct quality – a tough, uninflected character of abbreviation in which embellishment is excluded. *The Bull* takes this even further; comprising relatively few parts, each of which is heavier and more massive than had been the case hitherto. This denial of elaboration is continued in

Straight Cut 1972
Steel, rusted and
painted silver
132 × 157.5 × 129.5 cm
Private collection, UK

Complexity and simplicity

the work's finish. Caro retained the steel in its raw state, wanting to emphasise and expose the sculpture's material reality.

This new approach was developed in *Ordnance* 1971. The work makes use of a new element: the saw-horse, a pre-fabricated tool-part. This appropriated shape is an important compositional device, effectively allowing Caro to reprise the table idea. In contrast to *Sun Feast* and *Orangerie*, here it forms a supporting level on which are positioned a number of I-beams, laid horizontally. The effect is one of severity, clarity, and open, contained space. The work's unpainted, literal quality advances sculpture towards the world of fabricated and engineered objects. At the same time, the entirely non-functional, indeed, musical, animation of space, affected by the regular rhythm of the saw-horse legs, locates the sculpture firmly within the domain of pure expression.

The works in the *Straight* series of 1972 (see p.26) were made in deliberate defiance of any suggestion of elegant sensuality, and they challenge the idea that the use of I-beams as the main elements in a sculpture was over. They use sections of I-beam, cut and shaped, and brought into angular, interlocking

configurations of space and form. Making the works was demanding and complicated because as each work progressed, there was a sense of proliferating possibilities, which took each work in new directions as well as generating ideas for other, related sculptures. Complexity, however, was not the only route. Concurrent with his work on the *Straight* series, the *Veduggio* sculptures (see p.30), which were made at the Ripamonte steel factory at Veduggio, Brianza in Italy, in 1972 and 1973, reveal a parallel, contrasting tendency leading to extreme formal simplicity, almost a blankness, in which the relation of parts is relatively understated. They embody the belief that a given sculptural statement is enough if said with confidence. The works declare themselves without equivocation – as irresistible facts, as if arising from nature itself. Significantly, there is a sense that these opposite tendencies arise from a common sensibility: the conviction that sculpture, whether complex or not, must be made more real, more literally a thing in itself.

The line of development begun in the *Veduggio* series continued in a series of large scale works made in 1974, also using soft-edge rolled steel, this time obtained from the Consett steel works in

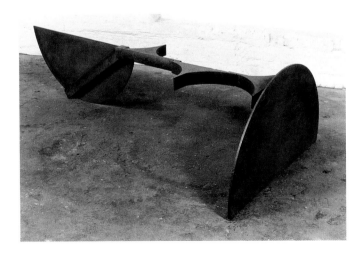

The Bull 1970
Steel, rusted
81.5 × 302.5 × 145 cm
Kenneth Noland

Ordnance 1971
Steel, rusted and varnished
129.5 × 193 × 636 cm
Collection of the artist

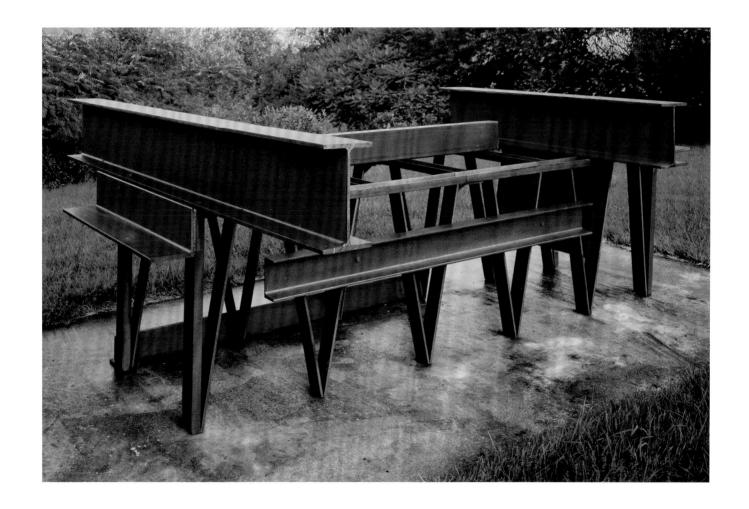

Durham, England. The thirty-seven works made at the York Steel Company in Toronto in the same year use thicker and heavier sheet steel. The *Veduggio*, *Durham* and *York* series trace a path towards larger and simpler formal arrangements, a way of working that brought to Caro's art that sense of expansive gesture and weight which in the 1960s he had eschewed.

During the 1970s, complexity and simplicity are parallel strands in Caro's work, revealing the principle of action and reaction that informs his way of working. Having, as it were, blanked out the sculpture's centre in the *Veduggio*, series, in *Midnight Gap* 1976–8 the centre is entirely animated by detail – indeed the sculpture seems *all* centre. This work is the sculptural equivalent of chamber music: an arresting structure built out of intricate detail, nuance and passages of expressive fancy.

Henceforward, a sculpture's centre – involving the exploration of its interior – becomes a primary theme of Caro's work. It forms the starting point for the *Emma* sculptures, the last major series of works that Caro made in the 1970s and the product of a two-week period spent in 1977 as artist in residence at the Emma Lake Summer Workshop under the auspices of the University of Saskatchewan. The fifteen sculptures that comprise the series were unlike anything Caro had made previously. They are entirely linear and open, almost cage-like. Mostly comprising steel tubing, they do not so much contain space as inscribe it – with economy and brevity. In making the *Emma* sculptures Caro had a particular motive. He later recalled: 'I was interested in the possibility of feeling my way into sculptural space from within, instead of without.'

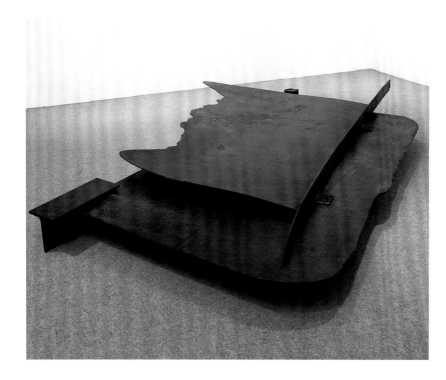

Veduggio Lago 1972–3
Steel, rusted and varnished
35.5 × 195.5 × 335.5 cm
Collection of the artist

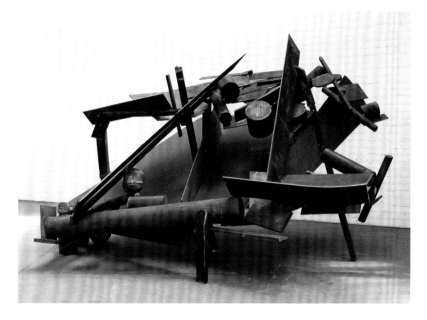

The *Emma* sculptures herald a new approach to making sculpture in which the interior is not simply exposed, but is as important as the work's exterior characteristics. In *Emma Dipper* 1977, for example, the sculpture does not really have an exterior, nor for that matter any definable centre. It incorporates a square, window-like element, hinting that one looks through and into the work. But such devices are playful. The sculpture probes the division between interior and exterior, and dissolves such distinctions. It exists as a kind of line drawing in air, exploring and animating space. The energy for this exploration comes from within the work, probing the surrounding space and simultaneously vacating the centre. Such works prepare the way for Caro's investigation of the interior of sculpture, which would be a dominant theme from the 1980s onwards.

Midnight Gap 1976–8
Steel, varnished and painted
180.5 × 361 × 279 cm
Private collection

Emma Dipper 1977
Steel, rusted and painted grey
213 × 170 × 320 cm
Tate. Presented by
the artist 1982

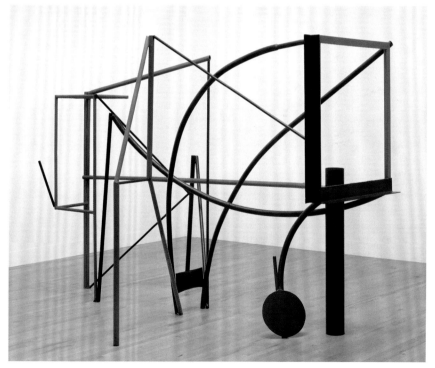

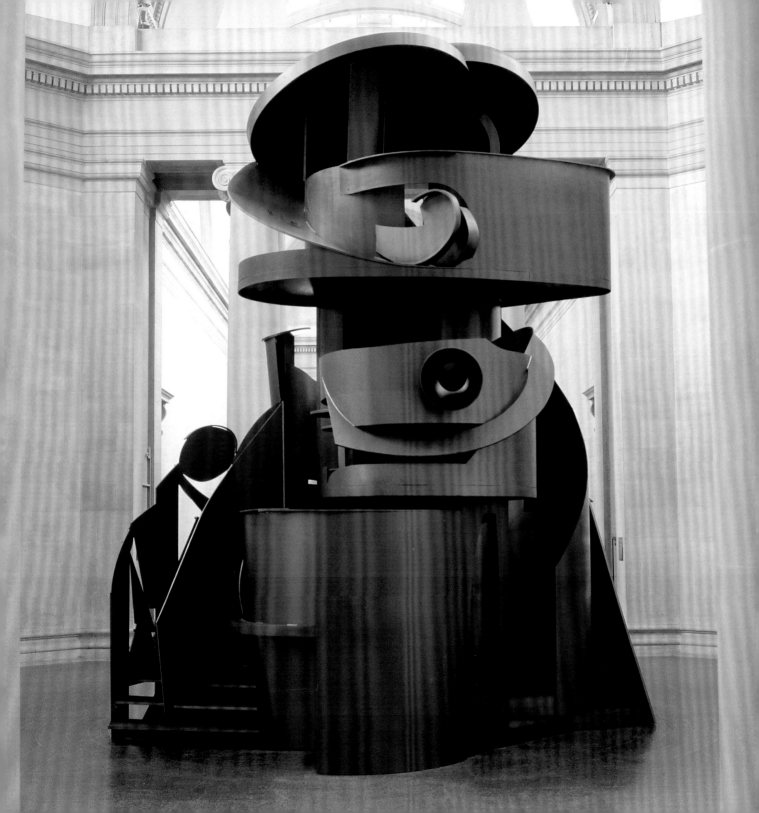

Throughout his career Caro has never stuck to one area of exploration. Each succeeding development has opened up fresh avenues, which he has pursued in directions that have never been predictable. The development of his sculpture from the 1980s to the present is one of ever increasing diversity. His work proceeds on a broad front, indeed several – often apparently contradictory – fronts simultaneously. It draws inspiration from painting and architecture and, whereas previously steel was his principal means of expression, increasingly Caro has fed that main tributary through his work in other media, notably bronze, lead, ceramic, stainless steel, silver, wood and paper. Such apparent contradictions have been a renewed source of energy. There is a sense that this is an artist aware that many of the old battles no longer need to be fought. The language for the new sculpture has been articulated, the case for its expressive power made. Caro explained: 'I felt much more freedom to experiment, freedom to try anything.'

This new approach can be glimpsed in the series of large sculptures using scrap steel found in shipyards that Caro made between 1982 and 1984. In these works, a vocabulary of heavy, maritime elements is deployed. Massive buoys, chain links and bollards are combined with sections of thick sheet steel, creating works that have greater weight, a revived complexity and an irrepressible physical presence. They seek volume, but this is conveyed without recourse to solidity or mass. Continuing the implications contained in the *Emma* sculptures, the exterior and interior of the works are held in suspension. The sculptures offer an exploded view of themselves. They advance surface and plane but at the same time they draw the eye to their internal recesses, chambers and cavities. A new element of mystery enters Caro's sculpture, as the works declare – sometimes openly and sometimes partly – their inner character. A principal element, unifying the series, is a large half-buoy. In many of the works, notably *Sheila's Song* 1982 (p.34), this shape suggests an open mouth. The sculptures remain abstract, but as the musical connotations of this and other titles

Tower of Discovery 1991
Painted steel
671 × 554 × 554 cm
Museum of Contemporary
Art, Tokyo

The figure and space

suggest, they allude to singing, songs and musical instruments, introducing an intriguing metaphorical element.

From the early 1980s the relationship of sculpture to architecture became an increasingly fertile field of enquiry for Caro. In 1982 he participated in *A New Partnership – Art and Architecture*, an exhibition held at the ICA, London. Caro showed a model of a walkway bridge for the City Library Building in Los Angeles, a proposal that took sculpture into the realms of functional, engineered objects. His next foray into this territory penetrated the principles of architecture while maintaining a non-functional, expressive distance. *Child's Tower Room* 1983–4 was created in wood for the *Four Rooms* exhibition, commissioned by the Arts Council of Great Britain in 1984. With this work, Caro advanced the idea of a sculpture that is no longer a purely visual experience. Continuing his earlier

dialogue between exterior and interior, the sculpture can be read as a kind of tower, with steps that lead from the outside into a contained, interior space. To experience the sculpture fully, the viewer enters the structure and responds physically to the interaction of its different shapes. Recalling the child's exploration of a tree-house or the space beneath the table, the sculpture evokes a world that is both real and make-believe.

In 1985 Caro visited Greece for the first time, an experience he had always resisted. As a student at the Royal Academy Schools, he had been familiar with Greek sculpture in the form of the innumerable brown plaster casts that lined the School's passages and life-rooms. These fragmented figures, isolated from their original setting, were presented by his tutors as the pinnacle of artistic achievement, but, even so, he refused to conform to the principle that to complete his education as an artist it was

Sheila's Song 1982
Steel, rusted and varnished
209.5 × 292 × 127 cm
Baltimore Museum of Art

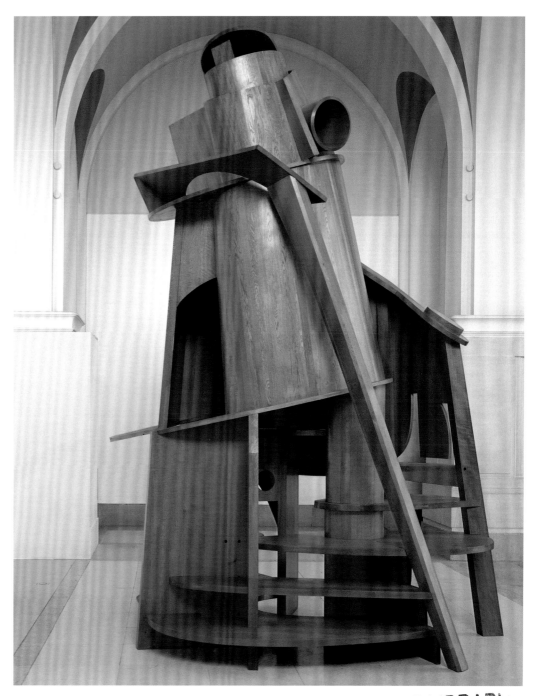

Child's Tower Room 1983–4
Japanese oak, varnished
381 × 274.5 × 274.5 cm
Private collection, UK

necessary to study classical art in situ. Finally seeing the great Greek temples, and those at Olympia and on the Acropolis in particular, therefore came as a revelation. Caro recalled:

> The light and the temples sited in their landscape made me see Greek art in a completely different way from studying photographs: the art and the history belong together. For me the most wonderful are the archaic sculptures, and also the pediments and metopes of Olympia. Instead of the sharded parts, that I know from my studies, I now saw the sculptures more as they were originally conceived – sensual rolling forms and figures contained and even forced into strict architectural shapes. The contrast of the volumetric moving forms is set against the crisp and geometric.

It is significant that Caro's response focused on the relation of the figure and space. A vital aspect of his work has always been his endeavour to bring about a fusion of feeling and form, creating sculpture that is neither expressionistic nor coldly formal. In *Child's Tower Room,* the viewer's body responds in a physical way to an architectonic space. *The Rape of the Sabines* 1985–6 interprets the pedimental sculpture he admired – but in a purely visual way. Its theme is that of containing rich, sensual, anthropomorphic shapes within an implied geometric context.

As a result, Caro opened up two separate lines of development in which the relation of figures to their context is a shared issue. Those sculptures that invite physical occupation by the viewer (which he playfully called 'sculpitecture' in an allusion to the fusion of sculpture and architecture) continued, in 1987, when he constructed a 'village' with the

After Olympia 1986–7
Photographed at Barford North, Ancram, New York
Steel, shot-blasted, rusted slightly and varnished
332.5 × 2342 × 170 cm
Etablissement public pour l'aménagement de la région de la défense, Paris

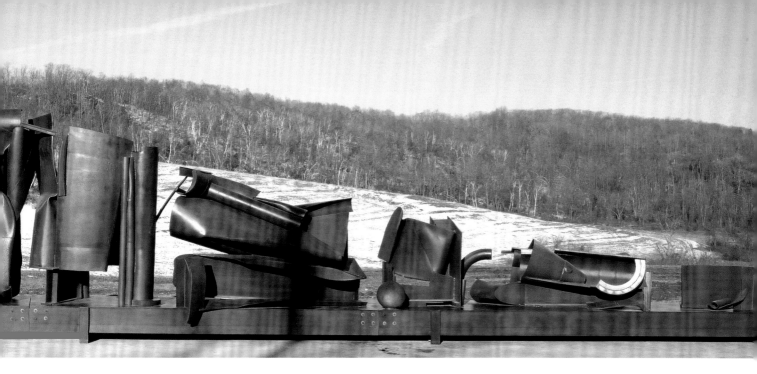

architect Frank Gehry. This was followed, in 1988, with two half-scale proposals for larger works, namely *Lakeside Folly* and *Pool House,* which were, like *Child's Tower Room*, made in wood. In these works Caro pushed sculpture towards architecture, towards the creation of spaces that can be entered. In 1990 the Tate Gallery commissioned him to make a sculpture that connected directly with a particular architectural setting: the Sackler Octagon, at the centre of the gallery's sculpture halls. Executed in steel, *Tower of Discovery* 1991 (p.32) was larger than its predecessors, and brought together many of Caro's long-standing preoccupations: exterior and interior space, steps and the idea of levels. Crucially, it intensified the experience of sculpture by drawing the viewer into a direct, physical relationship with its formal and spatial layout. All these works occupy the territory between architecture and sculpture: permitting exploration but, in formal terms, built freely and expressively. As such, they press architecture at its borders, but step back, maintaining sculpture's adherence to imagination over function.

At the same time, the purely visual aspect of his investigation of architectural themes continued in 1987 with *After Olympia*, at that time his largest work to date. Described by Caro as 'a kind of War and Peace sculpture' – an allusion to its vast scale and ambitious complexity – it took further his interpretation of Greek pedimental sculpture. Inspired by the art and architecture of the Temple of Zeus at Olympia, the sculpture is an abstract meditation on the relation of soft, sensual forms contained within a suggested triangular space: the human and the geometric in opposition and harmony.

The late 1980s onwards has seen an ever increasing cross-fertilisation between Caro's sources of inspiration. His art has not only opened itself to a range of new external influences – painting, architecture and the presence of the human figure – but has actively *married* those different ingredients, generating – almost from within itself – new possibilities and fresh challenges. As Caro has observed: 'the work itself takes over.'

This process was evident in the creation of *Xanadu* 1986–8 (p.40), an imposing sculpture originally conceived as a complement to *After Olympia*. Like that larger work, Xanadu was also inspired by Greek pedimental sculpture. But at some point in its long evolution, it veered away from this line of thought and began to take on an entirely unexpected significance. Gradually *Xanadu* became associated with one of Caro's favourite paintings, Matisse's *Bathers by a Stream* 1916–17, echoing the positions of the figures in the painting. That said, there is no suggestion that the sculpture was in any sense abstracted from the Matisse. Indeed, *Xanadu* contains the vestiges of an architectural arrangement in the way that the elements rise from the right-hand side to what would have been the apex of the pediment. At the same time, however, *Xanadu* is inhabited by the ghost of its pictorial ancestor.

A similar confluence of different elements permeates *Night Movements* 1987–90 (p.41). While the work was in progress, the steel suggested those qualities of volume and weight that Caro associated with Courbet's paintings. But as an arrangement of four physically separate parts, the work also raised an issue more usually associated with architecture: how to relate and unify unconnected elements so that they cohere within an overall structure. In this respect, *Night Movements* can be seen as an intriguing variation on the theme of sculpture that the viewer occupies physically. By walking around and within the sculpture's open arrangement, the viewer experiences its exterior and interior as a *continuum* – sensing its scale and the proximity, relation and character of the individual forms. Through that physical – but purely visual – relationship with the work, the viewer becomes an

The Last Judgement 1995–9
Stoneware, wood, steel, brass, bronze, concrete and plaster
Collection Würth, Künzelsau

Expanding the boundaries of sculpture

active participant, drawing the sculpture into a connected whole.

In both *Xanadu* and *Night Movements*, painting and architecture were vitalising elements, though not explicitly so, but from the mid-1980s, Caro began to address painting more overtly as source material for particular sculptures. In painting, space is evoked in an illusionistic way so the challenge was to invent an analogous space in three dimensions, creating sculpture that is commanding on its own terms. His major late ceramic sculpture, *The Moroccans* 1984–7, for example, is an intriguing piece, which builds on the spatial implications of Matisse's 1916 painting of that title. In addition, between 1987 and 1989 he completed four sculptures after works by earlier Masters, namely *Descent from the Cross I – After Rubens* 1987–8 (p.42) and *Descent from the Cross III – After Rembrandt* 1988–9, followed by two major table sculptures on a new, grander scale, *Déjeuner sur l'herbe I* 1989 (inspired by Monet's painting of that title) and *Déjeuner sur l'herbe II* 1989 (after Manet). In contrast to his sculpture that related to Greek pediments, these pictorially-inspired works are much closer to their source. Rather than an abstract response to a pre-existing work of art, they abstract *from* a pre-existing image. In these works Caro runs close to painting, seeking in these Masters' solutions to particular pictorial problems new points of departure for sculpture. In all these

Xanadu 1986–8
Steel, rusted and waxed
240 × 622 × 160 cm
Tate. Lent by a private collector 1994

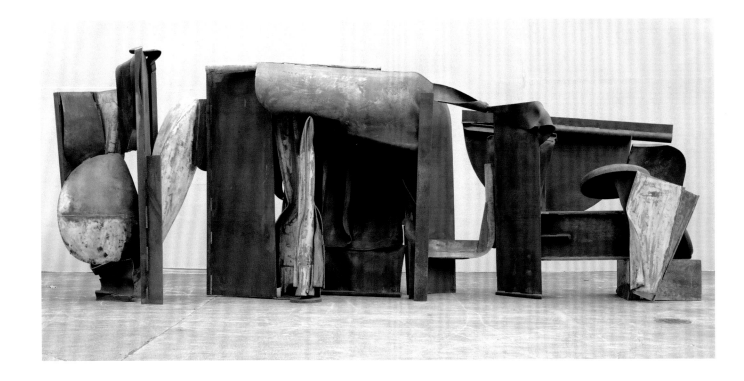

Night Movements 1987–90
Steel, stained green,
varnished and waxed
276 × 1077 × 335 cm
Tate. Purchased with
funds provided by the
Kreitman Foundation 1994

works, the evocation of flesh – mortal and sensuous – is tangible.

In recent years, the dialogue between Caro's sculpture and architecture has combined with his renewed interest in the human figure, achieving a remarkable communion between all these concerns. *Elephant Palace* 1989, *Night and Dreams* 1990–1 (see p.43) and *Requiem* 1993–6 restore to Caro's art a sense of skin which is now partly architectonic and part body. They suggest objects or habitable places – a building, a table, even a mausoleum – and they have a real, tangible, insistent presence. But in each case, this physicality is offset by the implied containment of some strange, inner life or ineffable energy. *Night and Dreams*, for

example, stands four-square on the ground and its outer planes are left deliberately blank, almost impassive. The work's principal interest lies *within* – in its inner recessed spaces and labyrinthine forms which invite an imaginative response from the viewer. Mystery and metaphor haunt these works, extending their expressive range into the realms of the psychological.

Recently, the investigation of space that is partly physical, partly psychological, has been a principal theme of Caro's art. From 1992 he has worked with the ceramicist Hans Spinner in the town of Grasse on the Cote d'Azur. In an echo of his work in clay in the 1950s, Caro engaged in a very physical and free way with Spinner's high density

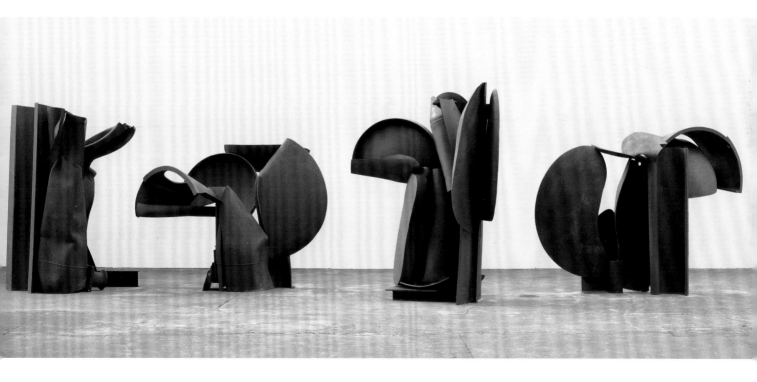

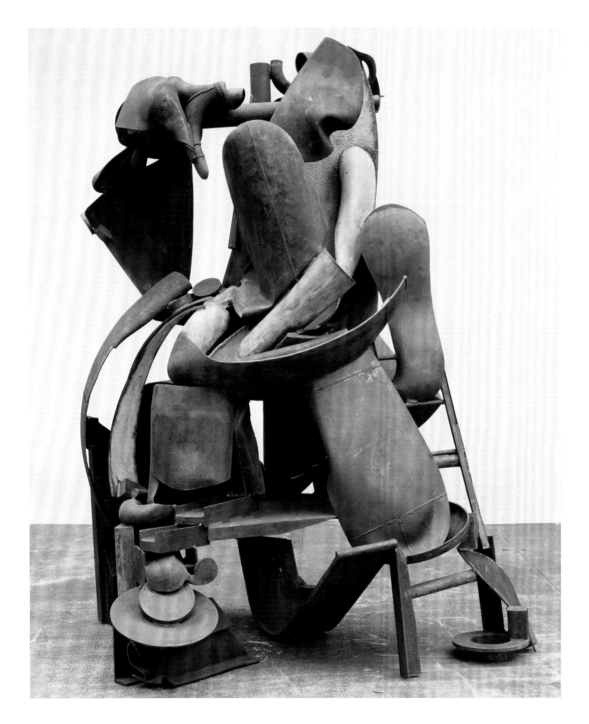

**Descent from the Cross I –
After Rubens** 1987–8
Steel, rusted and waxed
244 × 185.5 × 160 cm
Modern Art Museum,
Fort Worth

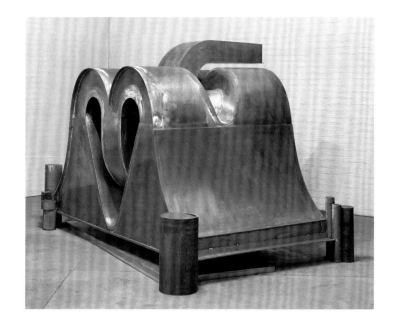

clay – beating and pushing the lumps, manipulating and dropping it – until, as Caro says, 'an image began to emerge'. As a result of that collaboration, he created a body of stoneware pieces – his raw material – that, between 1993 and 1994, yielded thirty-eight individual sculptures on the subject of the Trojan War (see p.44). In a fresh departure, wood and metal parts were combined with the fired stoneware, deepening and fixing the work's evolving character. In a final, further acknowledgement of his previous practice, a number of the pieces incorporate parts that function as pedestals, positioning the works somewhere between the real and the virtual. The result marks an extraordinary development in Caro's art: a complex multi-part piece through which the viewer moves. Combining the frankly figurative, the abstracted and the purely abstract, the individual parts are arranged as a kind

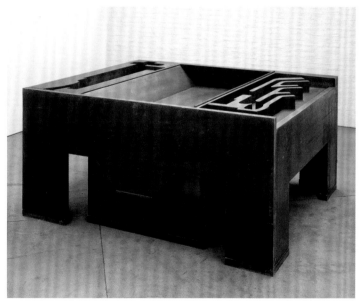

Elephant Palace 1989
Brass, welded
188 × 303.5 × 190.5 cm
Collection of the artist

Night and Dreams 1990–1
Steel, bolted, welded and waxed
104 × 223.5 × 188 cm
Collection of the artist

of tableau. Each evokes one of the gods or heroes from Homer's *Iliad* – Caro's source – and collectively they form a visual epic. *The Trojan War* takes sculpture towards drama, in which the viewer is an active, implicated protagonist.

The Trojan War implied an expanded physical and psychological context for sculpture, implications which received magisterial expression in the even more ambitious multi-part sculpture that followed. *The Last Judgement* 1995–9 (p.38) is one of Caro's most personal works: a sustained, emotive indictment of human cruelty and a tragic meditation on its effects. Caro's subject is the world as it is

now: a stage on which unfolds human catastrophe, unbelievable and indefensible suffering, a tragedy written in blood. Nothing is identified but the references are all too familiar, images ingrained from news footage of war, ethnic cleansing and devastation. Developing ideas contained in *The Trojan War*, the work comprises numerous individual parts – twenty-eight in all – many of which are fully developed as tableaux in their own right. *Civil War*, for example, is an evocation of numerous figures in an architectural setting. Others, such as *Flesh* and *Jacob's Ladder*, suggest human remains. Many of the works are in confining boxes – no longer sensuality

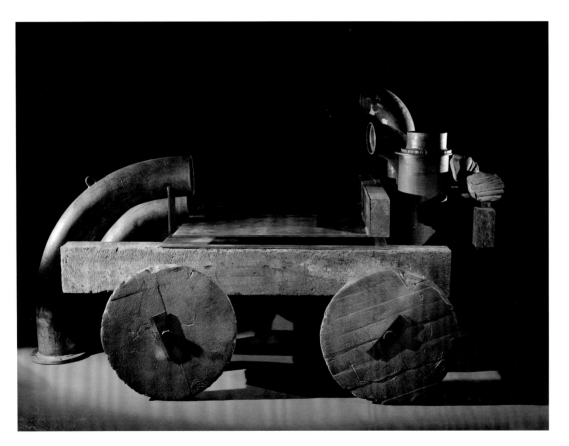

The Trojan Horse 1993–4
Stoneware, steel and
Jarrah wood
193 × 351 × 219 cm
Private collection

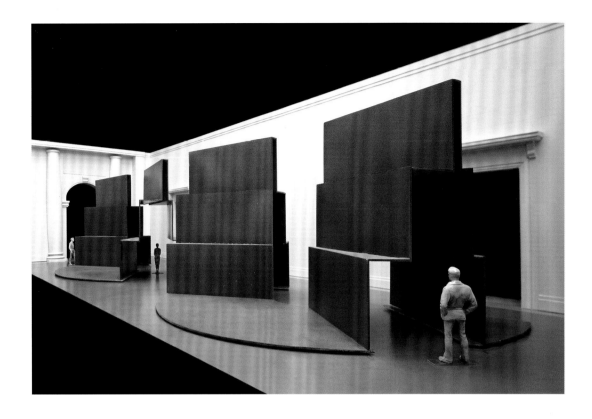

contained, but, rather, hatred and suffering compressed. Wood, stone, steel, brass, ceramic and concrete take on a new connotation of bitterness; and his language – representational, abstracted and abstract – seems calculated in its dissonance, entirely at one with its subject.

The relationship of the real and that which lies just beyond – occupying the territory of art – has always informed Caro's endeavour as a sculptor, and he continues to probe the line between the two. For example, his recent architectonic sculpture has assumed an even larger scale, taking it ever closer to architecture. *Halifax Steps: Spirals* 1994 and *Babylon* 1997 – one in steel, the other in wood – both use steps as a basic, instantly recognisable

element. However, it is equally clear that the context of sculpture places this feature beyond use. Caro's engagement is with the idea of steps. He deploys these elements freely and poetically; creating new structures that occupy the real space of the world but at the same time, stand apart from it. Caro's most recent work in this vein, *Millbank Steps* 2004, operates on precisely this double level. Commissioned for his major retrospective exhibition at Tate Britain in 2005, its large internal spaces invite physical exploration and, indeed, it suggests a building. However, during its construction, it was itself contained by a building. In architectural terms, that which is real contains that which is implied.

Few artists succeed in creating new standards by which art is judged. But this is the essence of Caro's achievement. While there are obvious precedents in the work of earlier artists making constructed sculpture, notably Picasso, González and David Smith, Caro's breakthrough in 1960 so effectively builds on the insights contained in these artists' work, and then extends those insights in such original and unexpected directions as to constitute a redefinition of the premises of sculpture. Further than any other sculptor before him, he took sculpture towards the realm of the real – and in doing so he disclosed a world of possibility.

Anthony Caro, 2000

Index of illustrated works

First published 2005 by order of the Tate Trustees on the occasion of the exhibition at Tate Britain, London by Tate Publishing, a division of Tate Enterprises Ltd, 26 Jan - 17 April 2005
Millbank, London SW1P 4RG
www.tate.org.uk

British Library cataloguing in publication data
A catalogue record for this book is available from the British Library

ISBN 1 85437 511 3

Distributed in the United States and Canada by Harry N. Abrams, Inc., New York

Library of Congress cataloging in publication data
Library of Congress Control Number: 2004111465

Designed by Philip Lewis
Printed in Italy

Dimensions are in centimetres, height before width

Front cover: Month of May 1963 (detail)
Frontispiece: Sculpture Two 1962 (detail)

Photographic credits

Works by Anthony Caro © Anthony Caro/Barford Sculptures Ltd, 2005

Photographs of works by Anthony Caro courtesy Barford Sculptures Ltd

Photographers: David Buckland
 Richard Davies
 John Goldblatt
 John Riddy

Willendorf Venus (p.8): Naturhistorisches Museum, Vienna/ www.bridgeman.co.uk